THE LITTLE

GREEN BOOK

THE LITTLE GREEN BOOK

Cherry Denman

STEWART, TABORI AND CHANG
NEW YORK

Copyright © 1990 Cherry Denman
PUBLISHED IN 1990 BY
STEWART , TABORI & CHANG
575 BROADWAY
NEW YORK , NEW YORK 10012 .

Library of Congress Cataloguing-in-Publication Card Number:89-52105
ISBN 1-55670-144-6
DISTRIBUTED IN THE U.S. BY
WORKMAN PUBLISHING
708 BROADWAY , NEW YORK , NY 10003
PRINTED IN ITALY
10 9 8 7 6 5 4 3 2 1

FIRST EDITION

~WITH THANKS TO~
Mark and Mindy Lucas
for saying it was a good idea.~
Alexandra Denman, Kate Westgarth & Chris Thomson
for saying they could help ~
Gail Rebuck
for saying yes ~
Joanna Roughton
for saying everything was fine
and
Charlie and Freddie
for saying nothing at all.

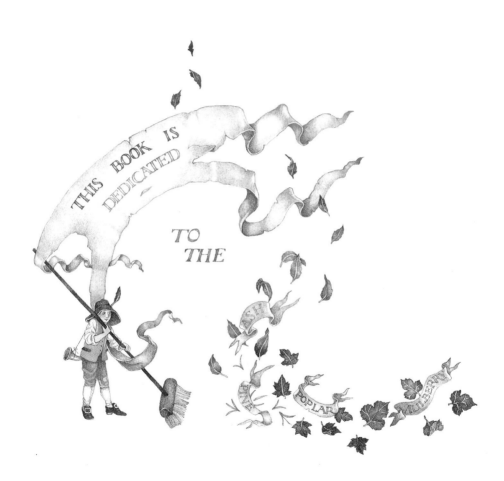

THIS BOOK IS DEDICATED TO THE ASH PINE POPLAR MULBERRY

THE CONTENTS

THE SEEDLING

THE SAPLING

THE TREE

THE FRUITING

THE FALLING OF LEAVES

THERE'S MUSIC IN THE
WAKING WOODS
THERE'S GLORY IN THE AIR ~

John Clare
Impulses of Spring.

SHOOTE · HIGH : : GREAT · OAKES ·

Oaks that flourish for a thousand years do
not spring up into beauty like a reed

~ Tall Oaks From Little Acorns Grow ·

~ David Everett ~ 1769–1813

Many a genius has been slow of growth

· BUT · TALL · CEDARS · FROM · LITTLE · GRAYNES ·

FROM · SLENDER · ROOTES · SPREAD · WIDE ·

George Henry Lewes ~ Spanish Drama ~ 1817–1878

· GOSSON ~ SCHOOL · OF · ABUSE ~ 1579 ·

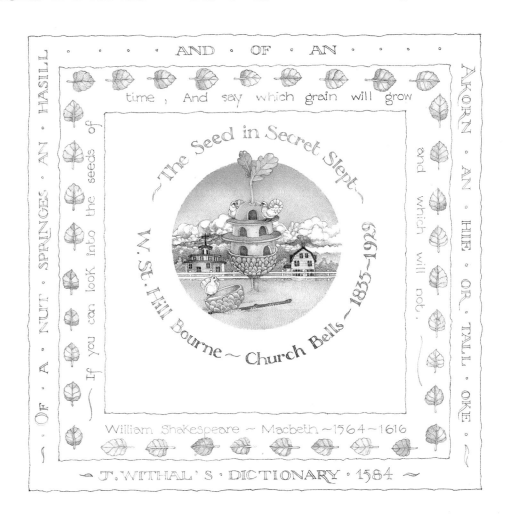

AND · OF · AN

time , And say which grain will grow

The Seed in Secret Slept

W. St. Hill Bourne ~ Church Bells ~ 1835~1929

William Shakespeare ~ Macbeth ~ 1564~1616

~ J. WITHAL'S · DICTIONARY · 1584 ~

HASILL · AN · SPRINGES · AN · NUTT · A · OF ~

of the seeds into look can you If

AKORN · AN · HIIF · OR · TAIL · OKE ·

and which will not.

JOB·12·8

SPEAK·TO·THE·EARTH, AND·IT·SHALL·TEACH·THEE·

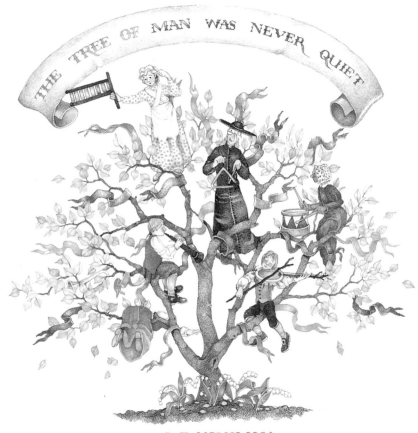

THE TREE OF MAN WAS NEVER QUIET

A.E.HOUSMAN
A shropshire lad
XXXI

ENTER THESE ENCHANTED WOODS, YOU WHO DARE.

LORD OF THE WOODS, THE LONG-SURVIVING OAK.

YEW THAT IS OLD IN CHURCHYARD-MOULD

ELMS, OLD MEN WITH THINNED-OUT HAIR,

WEEDS ARE GIFTS TOO CHOICE TO THROW AWAY

THE ASPEN PALES AND WHISPERS, HESITATES.

GEORGE
MEREDITH

WILLIAM
COWPER

RUDYARD
KIPLING

GEOFFREY
GRIGSON

JOHN
CLARE

SEAMUS
HEANEY

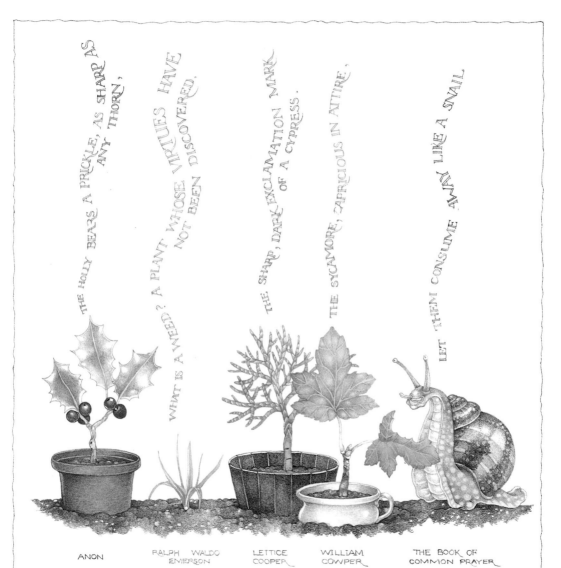

THE HOLLY BEARS A PRICKLE, AS SHARP AS ANY THORN,

WHAT IS A WEED? A PLANT WHOSE VIRTUES HAVE NOT BEEN DISCOVERED.

THE SHARP, DARK EXCLAMATION MARK OF A CYPRESS.

THE SYCAMORE, CAPRICIOUS IN ATTIRE,

LET THEM CONSUME AWAY LIKE A SNAIL

ANON

RALPH WALDO EMERSON

LETTICE COOPER

WILLIAM COWPER

THE BOOK OF COMMON PRAYER

L'EMBARRAS DES RICHESSES.
THE MORE ALTERNATIVES,
THE MORE DIFFICULT THE CHOICE.

Abbé D'Allainval
Title of Comedy

IS THERE IN THE WORLD
A CLIMATE MORE UNCERTAIN
THAN OUR OWN?

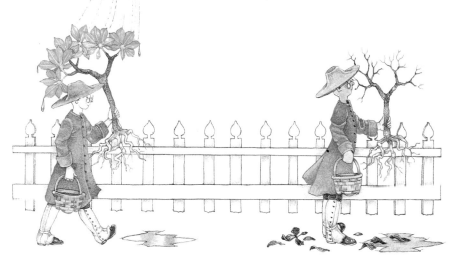

William Congreve
Amendments of Mr. Collier's False and Imperfect
Citations.

THEY SEED SO EFFORTLESSLY

TASTING THE WINDS, THAT ARE FOOTLESS,

WAIST-DEEP IN HISTORY—

WINTER TREES

Sylvia Plath

HOW LONG DOES IT TAKE TO MAKE THE WOODS?
AS LONG AS IT TAKES TO MAKE THE WORLD.

FROM SABBATHS

Wendell Berry

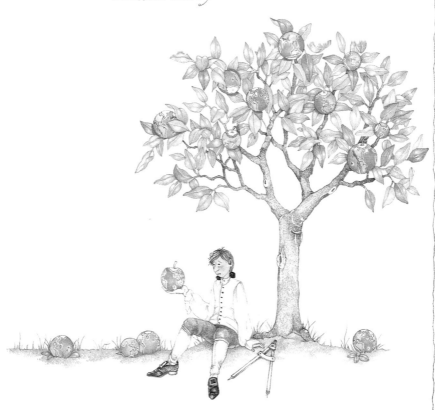

Microscopic purses, little beads,
Each holding in its patient dark a store
Of apples, flowering orchards, countless
seeds.

Vernon Scannell
APPLE POEM

ISAIAH Ch.2 V.4

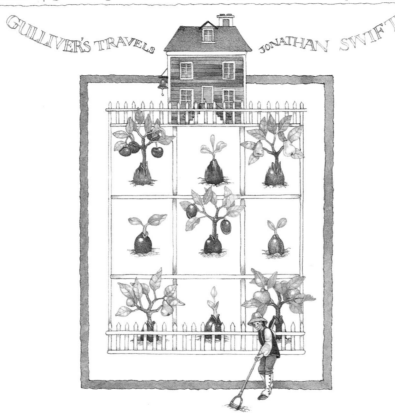

two blades of grass to grow upon a spot of ground where only one grew before, would deserve better of mankind, and do more essential service to his country than the whole race of politicians put together: ~ And he gave it for his opinion, that whoever could make two ears of corn or

GULLIVER'S TRAVELS · JONATHAN SWIFT

VOYAGE TO BROBDINGNAG

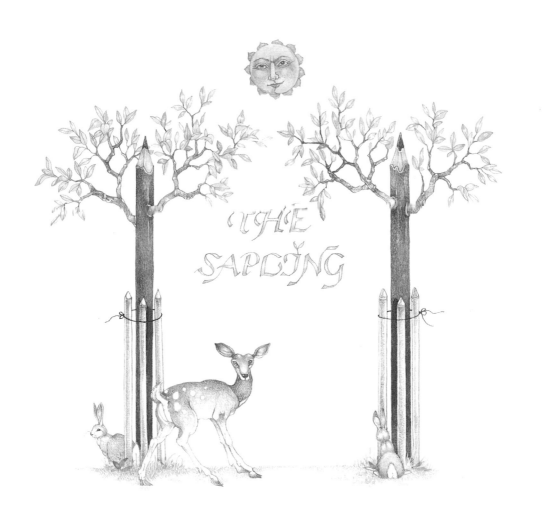

THE
SAPLING

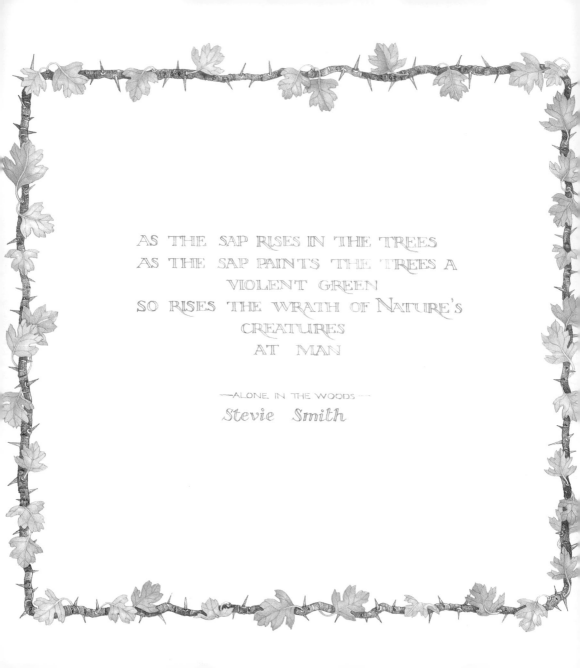

AS THE SAP RISES IN THE TREES
AS THE SAP PAINTS THE TREES A
VIOLENT GREEN
SO RISES THE WRATH OF NATURE's
CREATURES
AT MAN

—ALONE IN THE WOODS—
Stevie Smith

WHAT IS ALL THIS JUICE AND ALL THIS JOY?
A STRAIN OF THE EARTH'S SWEET BEING
IN THE BEGINNING
IN EDEN GARDEN ~ HAVE, GET, BEFORE
IT CLOY.

~Spring~
Gerard Manley Hopkins

EVERY GREEN WAS YOUNG, EVERY PORE
WAS OPEN, AND EVERY STALK WAS
SWOLLEN WITH RACING CURRENTS OF
JUICE.

~ Far From The Madding Crowd ~
Thomas Hardy

AND·FIRE·GREEN·AS·GRASS
DYLAN·THOMAS·
SHADE·
·THOUGHT·IN·A·GREEN·
ANNIHILATING·ALL·THAT'S·MADE·
·TO·A·GREEN·
TIME·HELD·ME·GREEN·
·AND·DYING·
ANDREW·MARVELL·
·THE·GARDEN·

A · PERFECT · FIRE · OF · GREEN ·
R · L · STEVENSON ·
AND · THIS · TREE · IS · GREEN · FIRE · IN · A · WORLD · OF · TREES ·
ALMOST · SUMMER · IN · THE ·
· HEART · OF · THE · WOODS ·
PETER · LEVI ·

· COLLECTED POEMS ·

GHOSTS OF THE WORLD-WOOD : THE TREES ARE FELLED,
STUMPS ; PUNY SAPLINGS WHICH REPLACE THEM
WILL OUTGROW ME AND THEN OUTLIVE ME.

~THE THICKET~
MICHAEL VINCE

THE TREES ARE COMING INTO LEAF
LIKE SOMETHING ALMOST BEING SAID;
THE RECENT BUDS RELAX AND SPREAD,
THEIR GREENNESS IS A KIND OF GRIEF.

⁓ THE TREES ⁓
PHILIP LARKIN

THEN·NATURE·APPROACHED·ME, CALLING·ME·BY·MY·NAME; AND·HE·BADE·ME·TAKE·HEED, AND·GATHER·WISDOM·FROM·ALL·THE·WONDERS·OF·THE·WORLD

· · · ~Piers the Ploughman · William Langland~ · · ·

I · WILL · UPHOLD · YOU, · TRUNK · AND · SHOOT · AND · FLOWERING · SHEAF, · AND · I · WILL · HOLD · YOU, · ROOT · AND · FRUIT · AND · FALLEN · LEAF ·

E. J. Scovell.

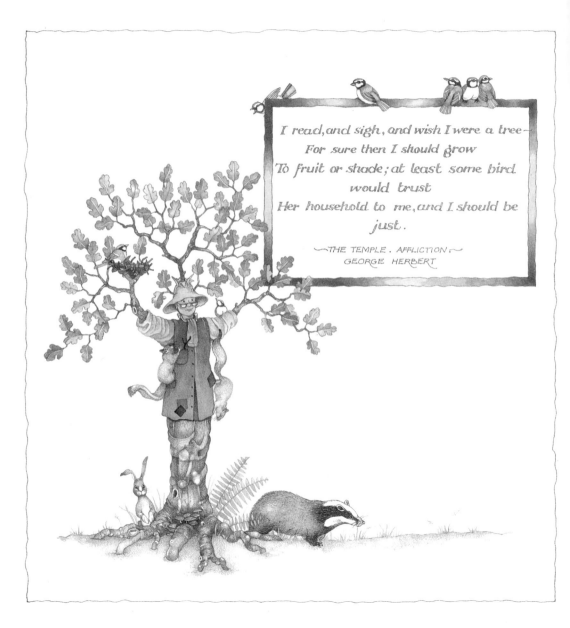

I read, and sigh, and wish I were a tree—
For sure then I should grow
To fruit or shade; at least some bird would trust
Her household to me, and I should be
just.

~THE TEMPLE. AFFLICTION:~
GEORGE HERBERT

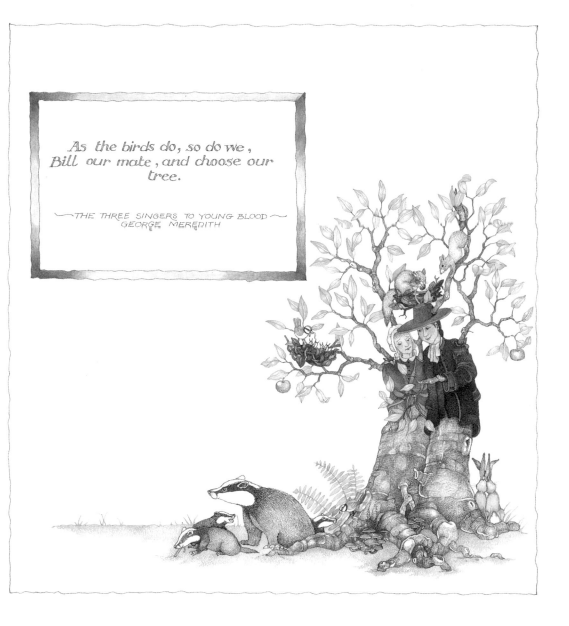

As the birds do, so do we,
Bill our mate, and choose our
tree.

~ THE THREE SINGERS TO YOUNG BLOOD ~
GEORGE MEREDITH

ROBERT HERRICK

NEW THINGS SUCCEED, AS FORMER THINGS GROW OLD.

Ceremonies for Candlemasse Eve ~

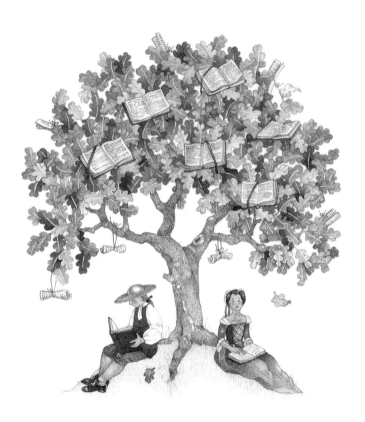

THE TREE.

AND · THE · LEAVES · OF · THE · TREE
WERE · FOR · THE · HEALING · OF ·
· THE · NATIONS ·

The Revelation of
St. John the Divine

xxii. 2

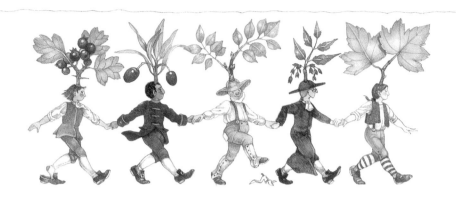

I SEE MEN AS TREES,
WALKING.

St. Mark
VIII 24

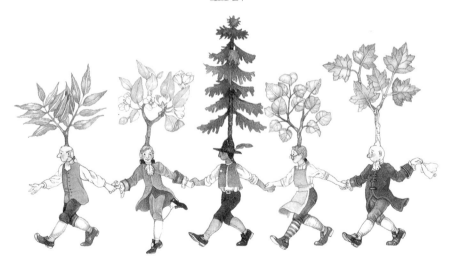

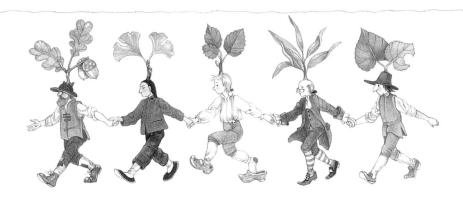

A BROTHERHOOD OF VENERABLE TREES.

William Wordsworth
Memorials of a Tour in Scotland
1803 xii

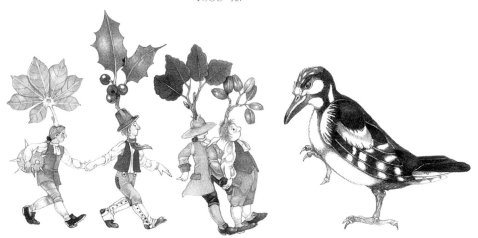

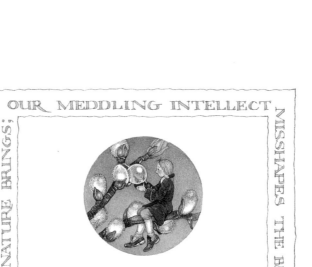

OUR MEDDLING INTELLECT
MISSHAPES THE BEAUTEOUS FORMS
OF THINGS. SWEET IS THE
LORE WHICH NATURE BRINGS;

One impulse from a vernal wood
May teach you more of man,
Of moral evil and of good,
Than all the sages can.

The Tables Turned.
William Wordsworth.

OF THINGS, LET

Trees that for twenty thousand
years
Your vows have kept,
You have suddenly healed the pain
of a traveller's heart,
And moved his brush to write a
new song

Chang Fang-Sheng 4ᵗʰ Century

COME FORTH INTO THE LIGHT

NATURE BE YOUR TEACHER.

WORDSWORTH

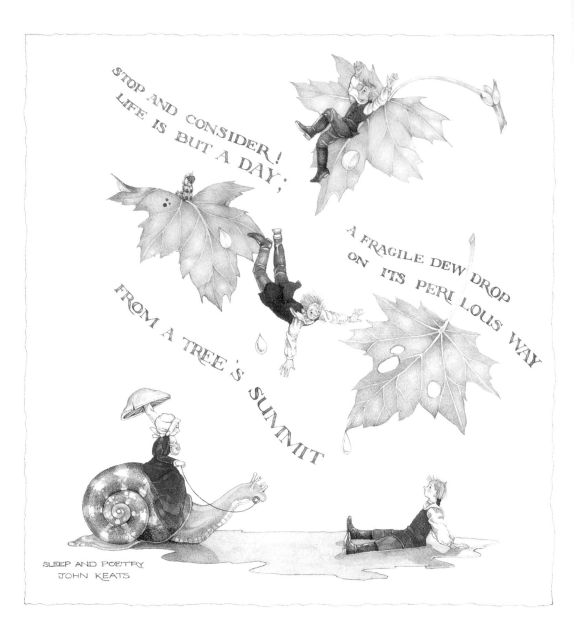

STOP AND CONSIDER!
LIFE IS BUT A DAY;

A FRAGILE DEW DROP
ON ITS PERILOUS WAY

FROM A TREE'S SUMMIT

SLEEP AND POETRY
JOHN KEATS

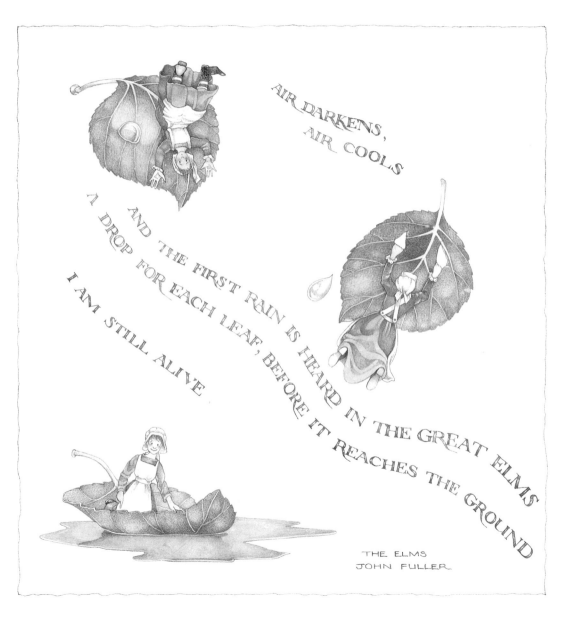

AIR DARKENS,
AIR COOLS

AND THE FIRST RAIN IS HEARD IN THE GREAT ELMS
A DROP FOR EACH LEAF, BEFORE IT REACHES THE GROUND

I AM STILL ALIVE

THE ELMS
JOHN FULLER

A FOOL SEES NOT THE SAME TREE THAT A WISE
MAN SEES.

WILLIAM BLAKE
PROVERBS OF HELL

THE TREE WHICH MOVES SOME TO TEARS OF
JOY IS IN THE EYES OF OTHERS ONLY A GREEN
THING WHICH STANDS IN THE WAY...

WILLIAM BLAKE
IN A LETTER TO THE REV. DR.
TRUSLER

I THINK THAT I SHALL NEVER SEE
A BILLBOARD LOVELY AS A TREE.
INDEED, UNLESS THE BILLBOARDS FALL
I'LL NEVER SEE A TREE AT ALL.

Song of the Open Road
OGDEN NASH

POEMS ARE MADE BY FOOLS LIKE ME,
BUT ONLY GOD CAN MAKE A TREE.

Trees
Poems, Essays & Letters
Joyce Kilmer

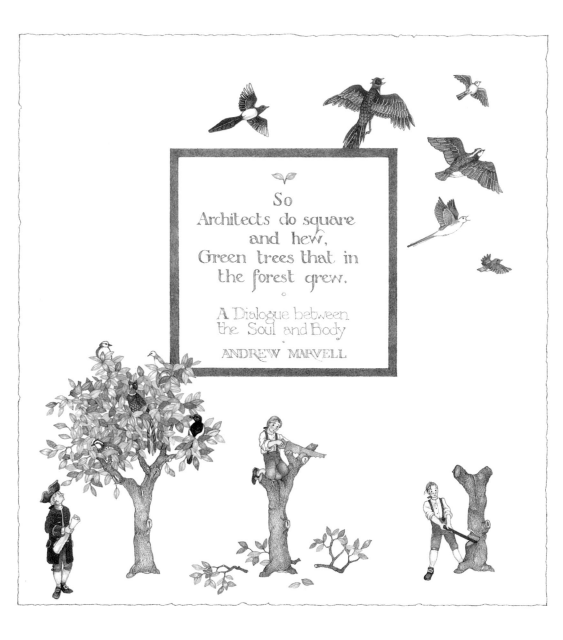

So
Architects do square
and hew,
Green trees that in
the forest grew.

A Dialogue between
the Soul and Body

ANDREW MARVELL

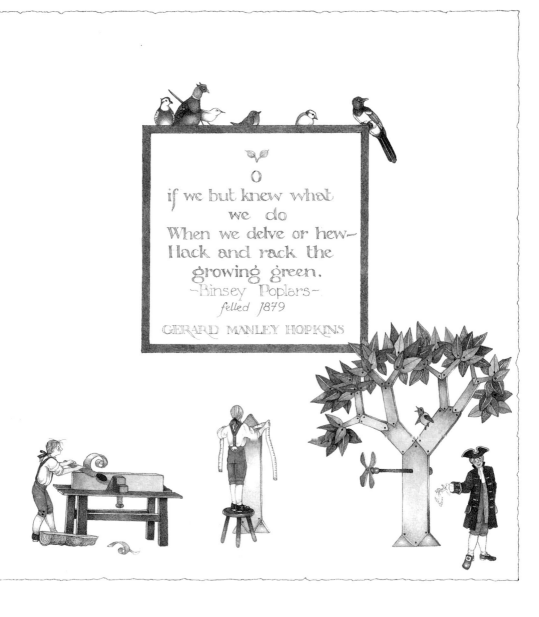

O
if we but knew what
we do
When we delve or hew—
Hack and rack the
growing green.
~Binsey Poplars~
felled 1879

GERARD MANLEY HOPKINS

ASH AND OAK, CHESTNUT
AND YEW;
WITNESSES, HUGE, MILD
BEINGS WHO SUFFER THE
CONSEQUENCE
OF SHARING OUR PLANET
AND CANNOT MOVE
AWAY FROM ANY EVIL
WE
SUBJECT THEM TO,

Trees
Ruth Fainlight

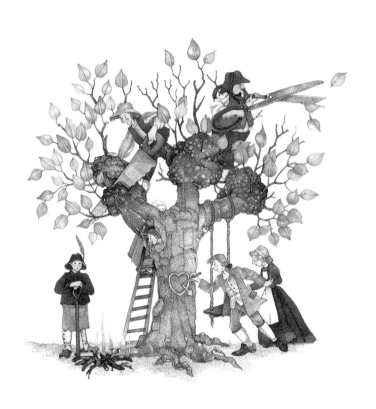

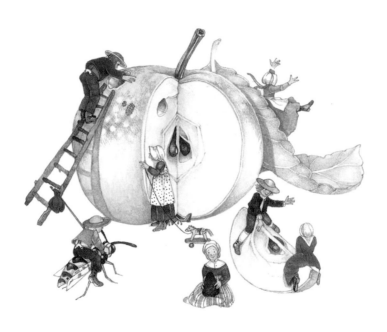

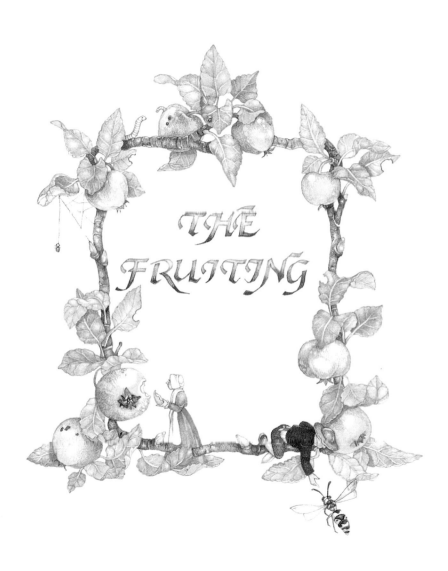

THE
FRUITING

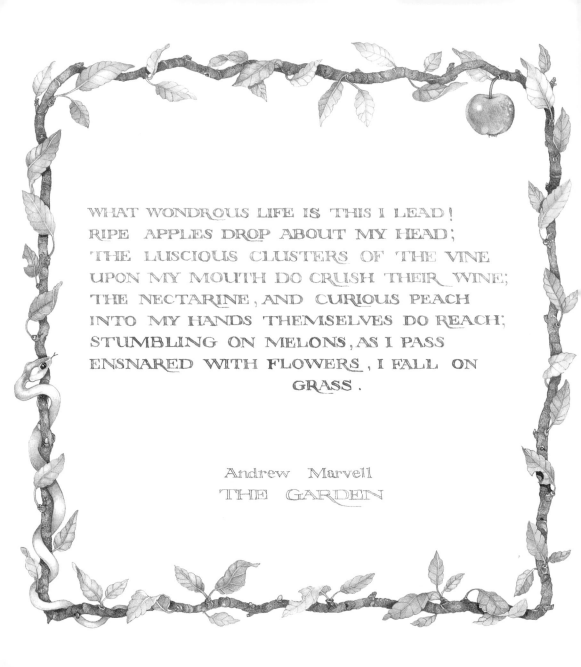

WHAT WONDROUS LIFE IS THIS I LEAD!
RIPE APPLES DROP ABOUT MY HEAD;
THE LUSCIOUS CLUSTERS OF THE VINE
UPON MY MOUTH DO CRUSH THEIR WINE;
THE NECTARINE, AND CURIOUS PEACH
INTO MY HANDS THEMSELVES DO REACH;
STUMBLING ON MELONS, AS I PASS
ENSNARED WITH FLOWERS, I FALL ON
GRASS.

Andrew Marvell
THE GARDEN

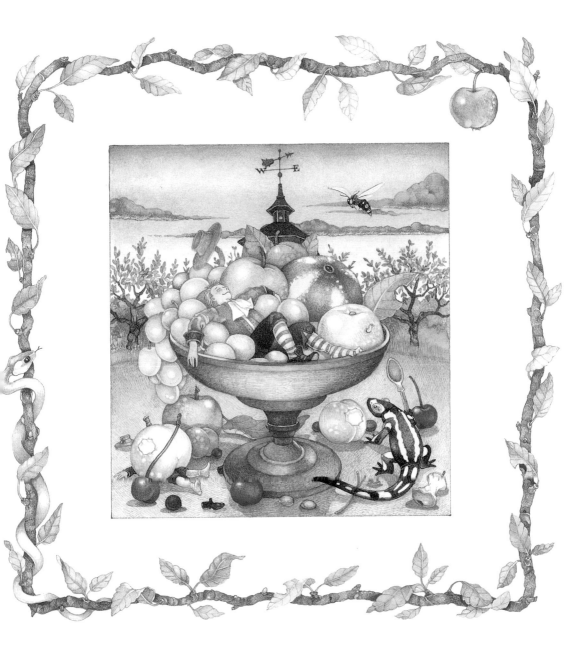

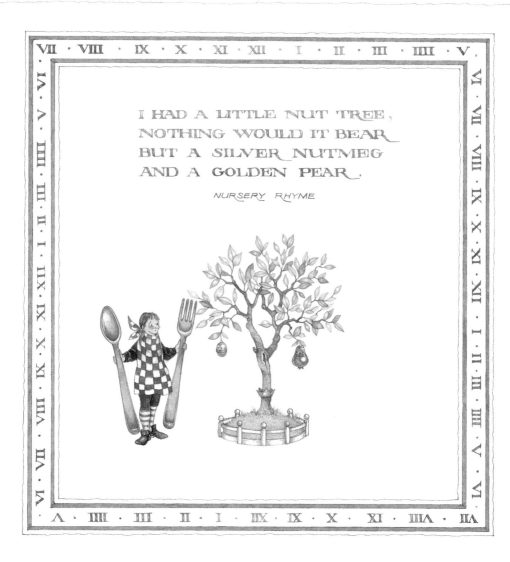

I HAD A LITTLE NUT TREE,
NOTHING WOULD IT BEAR
BUT A SILVER NUTMEG
AND A GOLDEN PEAR.

NURSERY RHYME

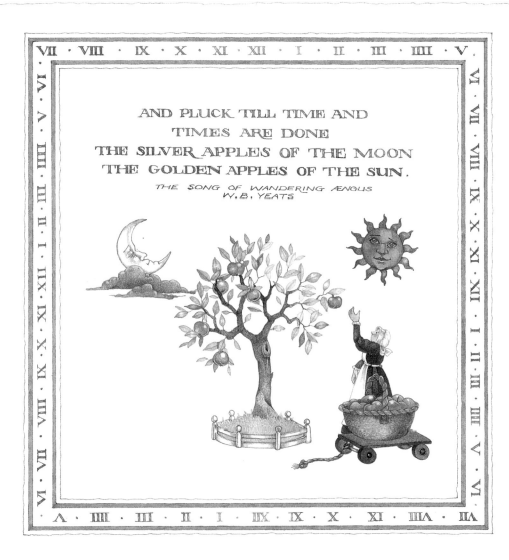

AND PLUCK TILL TIME AND
TIMES ARE DONE
THE SILVER APPLES OF THE MOON
THE GOLDEN APPLES OF THE SUN.

THE SONG OF WANDERING ÆNGUS
W.B. YEATS

BUT APPLES PLANTS OF SUCH A PRICE,
NO TREE COULD EVER BEAR THEM TWICE.

Bermudas
Andrew Marvell

...BESPANGLED AND GORGEOUSLY APPARELLED
WITH GREEN LEAVES, BLOOMS AND GOODLY
FRUITS AS WITH A RICH ROBE OF
EMBROIDERED WORK...

A Treatise of Fruit Trees
Ralph Austen

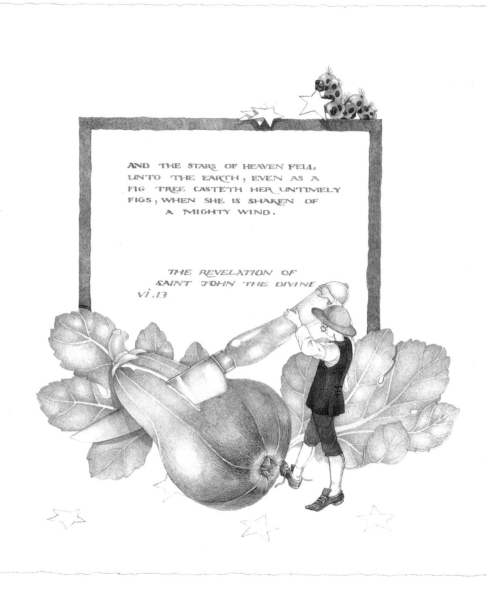

AND THE STARS OF HEAVEN FELL
UNTO THE EARTH, EVEN AS A
FIG TREE CASTETH HER UNTIMELY
FIGS, WHEN SHE IS SHAKEN OF
A MIGHTY WIND.

THE REVELATION OF
SAINT JOHN THE DIVINE
vi.13

THE FIG TREE PUTTETH FORTH
HER GREEN FIGS, AND THE VINES
WITH THE TENDER GRAPE GIVE
A GOOD SMELL. ARISE MY LOVE,
MY FAIR ONE, AND COME AWAY.

THE SONG OF SOLOMON 2:9

FROM THE GREENGROCER TREE
YOU GET GRAPES AND GREEN PEA,
CAULIFLOWER, PINEAPPLE, AND
CRANBERRIES

Sir William Schwenk Gilbert

IOLANTHE

ALL HEDGEROWS SHOULD BE PLANTED
WITH FRUIT TREES AND THOSE THAT
PICKED IT TO SATISFY THEIR OWN
HUNGER SHOULD GO UNPUNISHED.

John Tavener

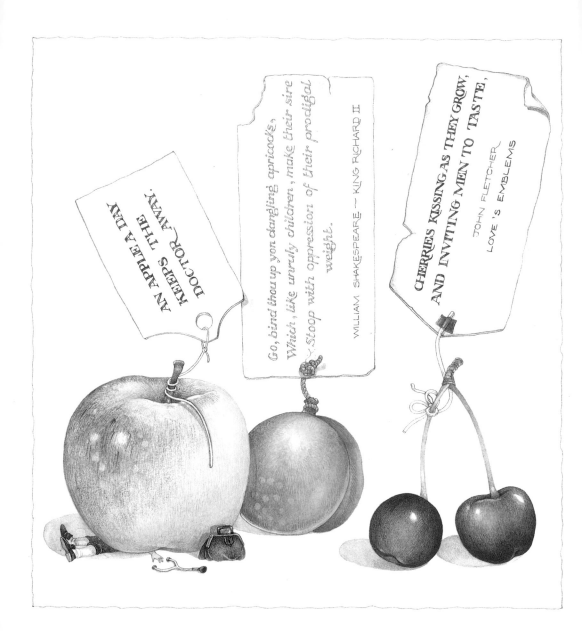

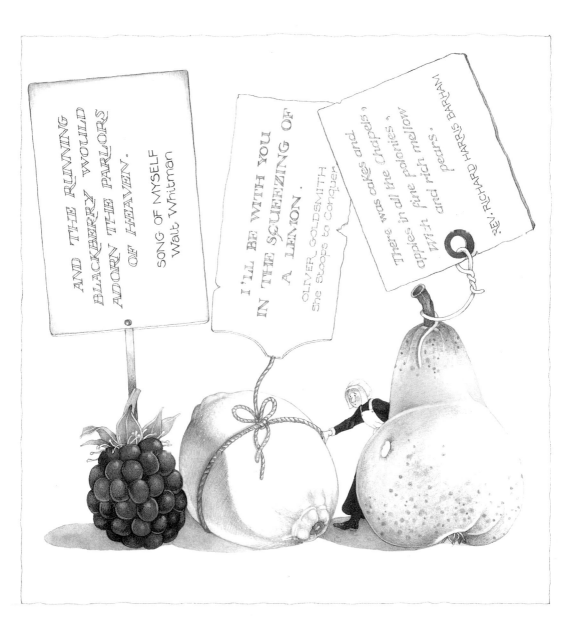

PARADISE LOST

Her rash hand in evil hour,
Forth reaching to the fruit, she pluck'd,
she eat:
Earth felt the wound, and Nature from her
seat
Sighing through all her works gave signs
of woe
That all was lost.

John Milton

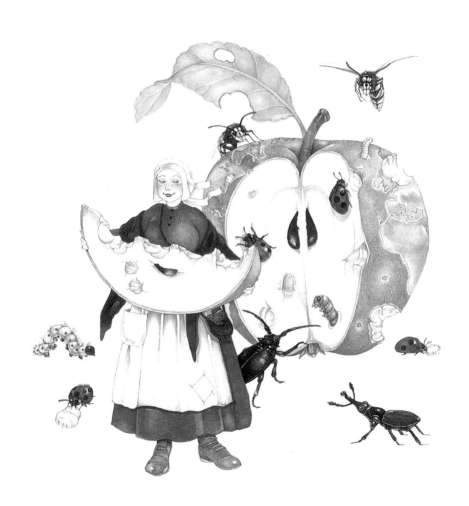

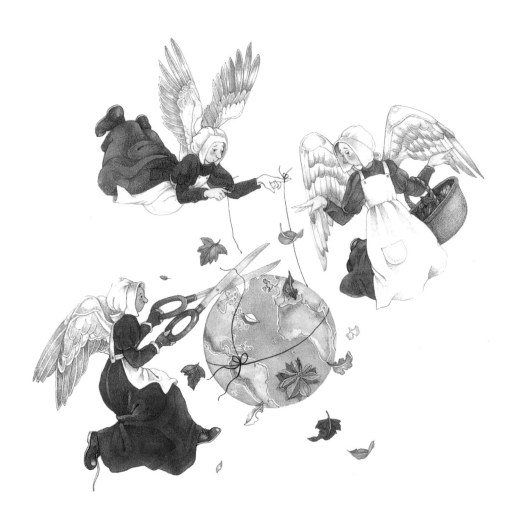

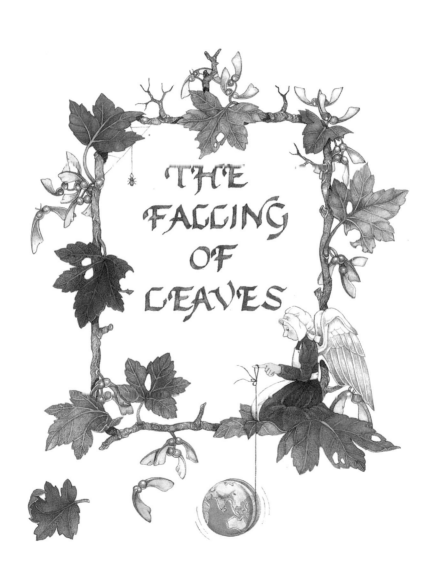

THE
FALLING
OF
LEAVES

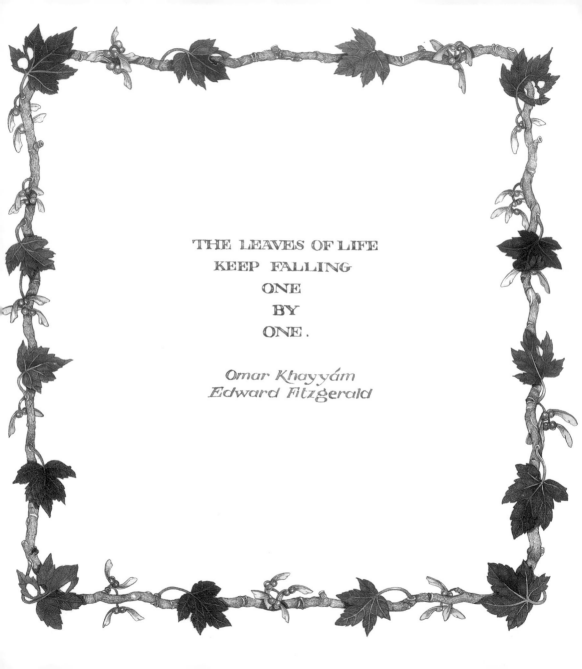

THE LEAVES OF LIFE
KEEP FALLING
ONE
BY
ONE.

Omar Khayyám
Edward Fitzgerald

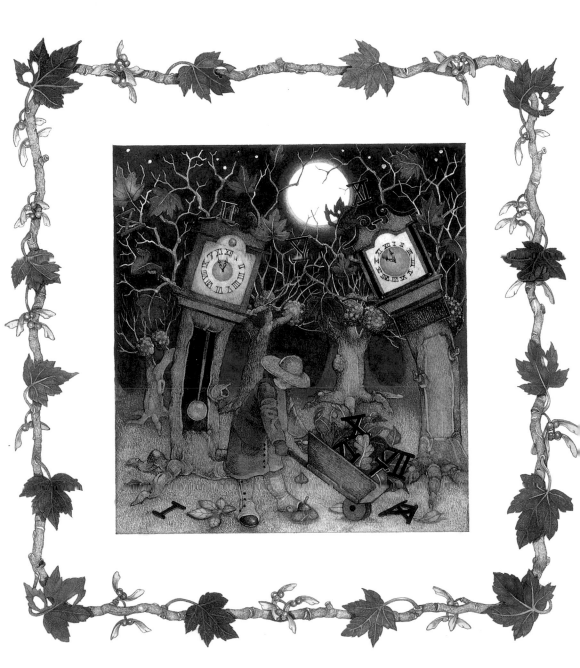

AND HEARD THE AUTUMNAL LEAVES
LIKE LIGHT FOOTFALLS
OF SPIRITS PASSING THROUGH THE
STREETS

ODE TO NAPLES
PERCY BYSSHE SHELLEY

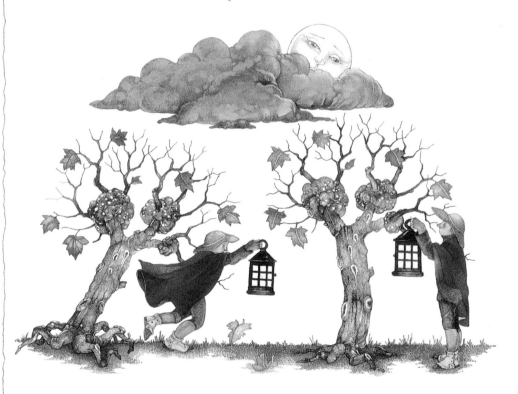

THE SPIRIT OF THE PLACE SEEMED
TO BE ALL ATTENTION; THE WOOD
LISTENED AS I WENT AND HELD ITS
BREATH TO NUMBER MY FOOTFALLS.

AN AUTUMN EFFECT
ROBERT LOUIS STEVENSON

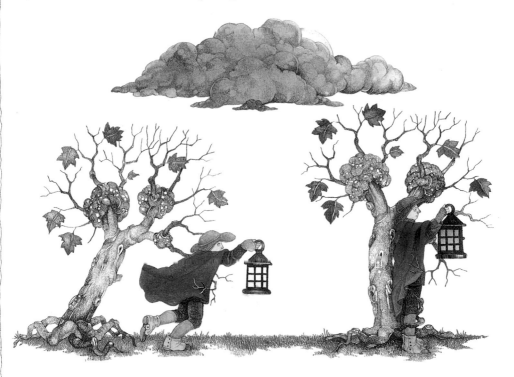

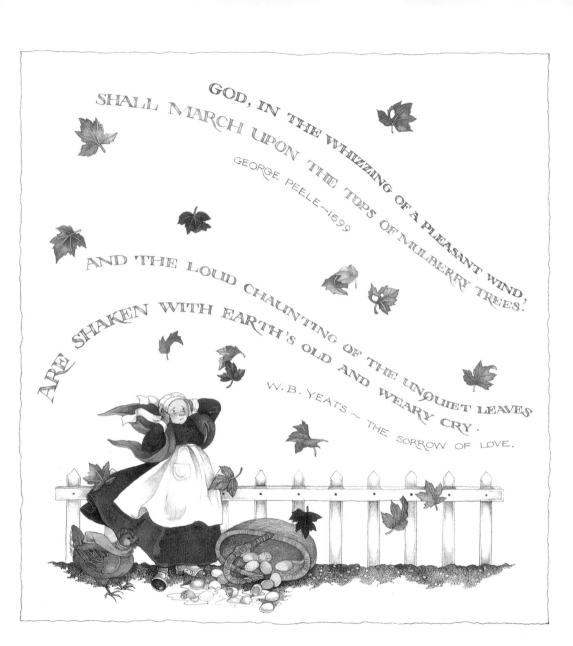

GOD, IN THE WHIZZING OF A PLEASANT WIND,
SHALL MARCH UPON THE TOPS OF MULBERRY TREES.

GEORGE PEELE ~ 1599

AND THE LOUD CHAUNTING OF THE UNQUIET LEAVES
ARE SHAKEN WITH EARTH'S OLD AND WEARY CRY.

W. B. YEATS ~ THE SORROW OF LOVE.

VAGUE RUMOURS THAT WENT
AMONG THE TREETOPS
ROBERT LOUIS STEVENSON ~ AN AUTUMN EFFECT.

WHISPERING WINDS THE POPLARS COURTING.
THOMAS BROWN

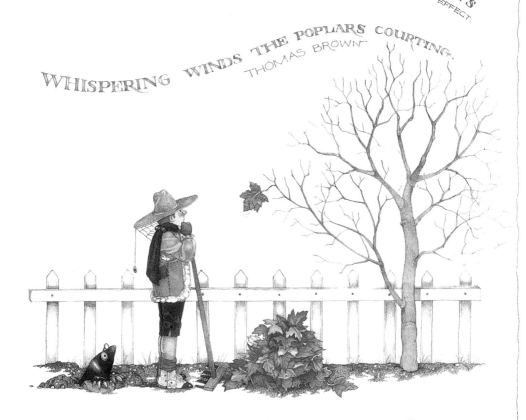

LEAVES FROM ETERNITY ARE SIMPLE THINGS.
JOHN CLARE

WITHOUT THE COMPANY OF LEAVES...
GILLIAN CLARKE

YOU LEAVES DRENCHED WITH THE LIFEBLOOD
OF THE YEAR ~
C. DAY LEWIS

TREES SCREAM AND DROP THEIR
BRIGHT LEAVES.

ALLEN GINSBERG

THE PERISHED LEAVES OF HOPE,

DANTE GABRIEL
ROSSETTI

AND WE ALL DO FADE AS A LEAF.

THE BIBLE

ILL FARES THE LAND, TO HAST'NING ILLS
A PREY,
WHERE WEALTH ACCUMULATES, AND MEN
DECAY

OLIVER GOLDSMITH
THE DESERTED VILLAGE

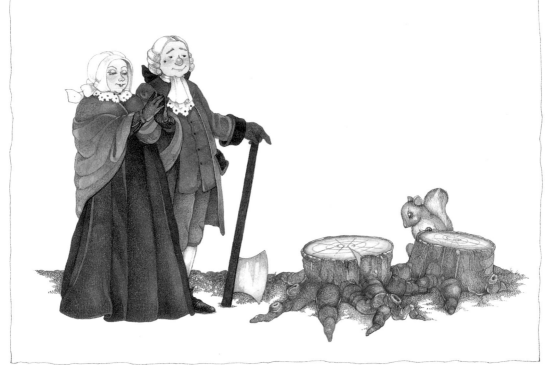

GIVE ME A LAND OF BOUGHS IN LEAF,
A LAND OF TREES THAT STAND;
WHERE TREES ARE FALLEN, THERE IS GRIEF;
I LOVE NO LEAFLESS LAND...

A. E. HOUSMAN

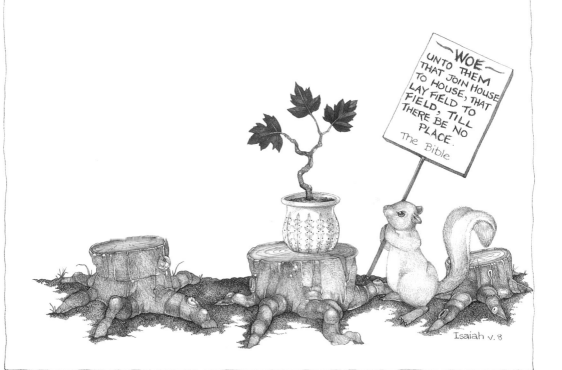

WOE
UNTO THEM
THAT JOIN HOUSE
TO HOUSE, THAT
LAY FIELD TO
FIELD, TILL
THERE BE NO
PLACE.

The Bible

Isaiah v. 8

SENSING US, THE TREES TREMBLE IN
THEIR SLEEP,
THE LIVING LEAVES RECOIL BEFORE OUR
FIRES.

KATHLEEN RAINE
LONDON TREES

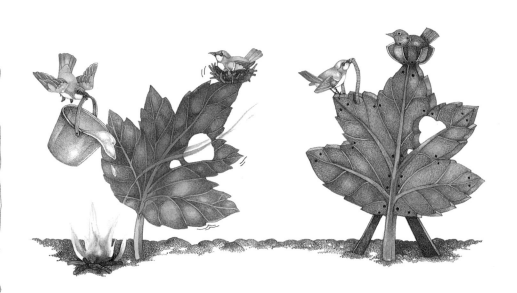

THE FOREST TURNED
FROM WOOD
TO STONE
TO DUST.

ANTHONY THWAITE.
DEAD WOOD

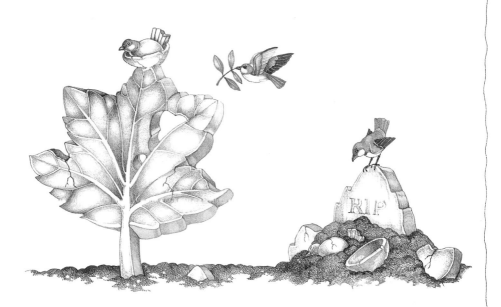

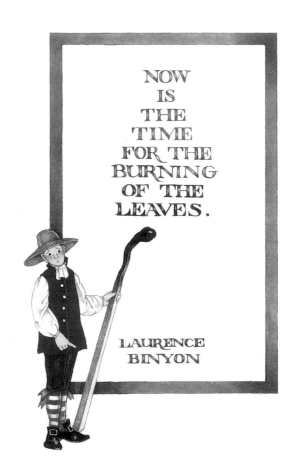

NOW
IS
THE
TIME
FOR THE
BURNING
OF THE
LEAVES.

LAURENCE
BINYON

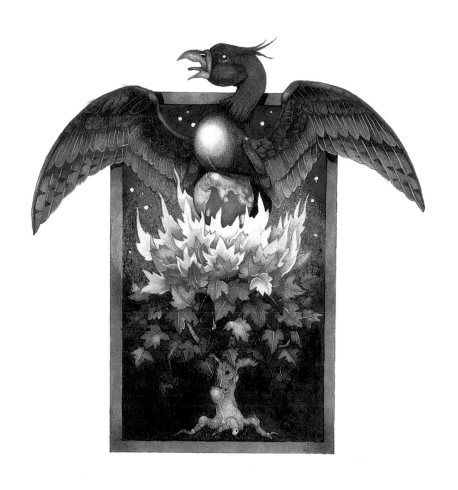

ACKNOWLEDGEMENTS

Every endeavour has been made to find copyright holders of quotations. Any infringement of copyright is inadvertent, and the publishers should be notified. Acknowledgement is made to the following for quotations used in this book.

'Alone in the Woods' from <u>The Collected Poems of Stevie Smith</u>, Stevie Smith Copyright 1972 Stevie Smith. Reprinted by permission of New Directions Publishing Corporation.

'Apple Poem' from <u>Funeral Games</u>, Vernon Scannell (Robson Books).

'Autumn Gold: New England Fall' from <u>Collected Poems 1947-80</u>, Allen Ginsberg (Penguin Books Ltd).

'The Betrothal' from <u>Collected Poems</u>, E.J.Scovell (Carcanet Press Ltd).

'The Bushy Leaved Oak Tree' from <u>Sweeny Astray - A Version from the Irish</u>, Seamus Heaney (Field Day Publications).

'Cardiff Elms' from <u>Selected Poems</u>, Gillian Clarke (Carcanet Press Ltd).

'Dead Wood' from <u>Poems 1953-83</u>, Anthony Thwaite (Martin Secker & Warburg).

'The Elms' from <u>Cannibals and Missionaries</u>, John Fuller. Reprinted by permission of Martin Secker & Warburg.

'Fenny' Lettice Cooper (Virago Press).

'Fern Hill' from <u>Poems of Dylan Thomas</u>, Dylan Thomas. Copyright 1945 by the Trustees for the copyright of Dylan Thomas. Reprinted by permission of David Higham Associates Ltd and New Directions Publishing Corporation.

'How long does it take to make the woods?' from <u>Sabbaths</u>, Wendell Berry (North Point Press).

'London Trees' from <u>Collected Poems</u>, Kathleen Raine (Hamish Hamilton Ltd).

'Maple and Sumach' from <u>Poems of C.Day Lewis 1925-72</u>, C. Day Lewis (Jonathan Cape Ltd).

'The Song of the Open Road' from <u>Collected Verse from 1929</u>,

copyright Ogden Nash , printed by permission of Curtis Brown , London
on behalf of the estate of Ogden Nash .

'The Thicket' from In the New District , Michael Vince (Carcanet Press).

'Trees' from Sibyls and Others , Ruth Fainlight (Hutchinson.).

'The Trees' from High Windows , Philip Larkin . Reprinted by permission
of Faber & Faber Ltd.

'Winter Trees' from Collected Poems , Sylvia Plath (Faber & Faber)
London. Copyright Ted Hughes 1971 and 1981 by permission of
Olwyn Hughes .

'The Wooden-Shouldered Tree is Wild and High' from Collected Poems
1955 - 1975 Peter Levi (Anvil Press Poetry)

And to the Grigson family for 'Elms Under Cloud' by Geoffrey Grigson
from the Collected Works of Geoffrey Grigson 1924 - 1962
Phoenix House 1963 (© Geoffrey Grigson 1963)

THANKS TO JO AND MIKE PARTON FOR GIV~ ING ME THE TIME .

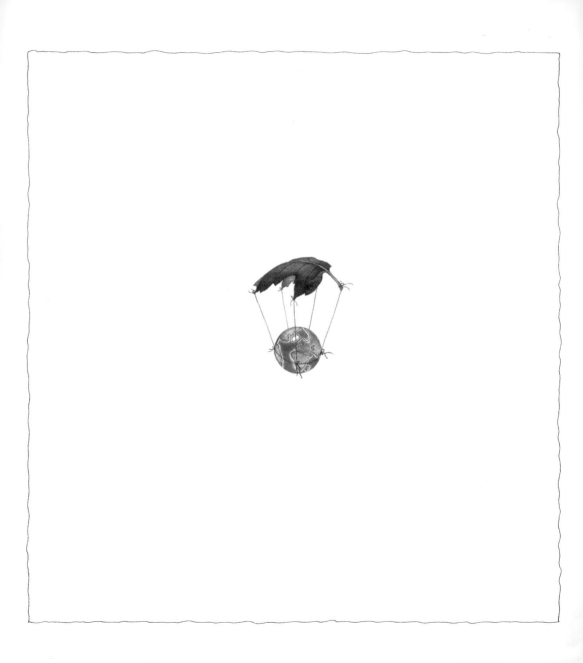

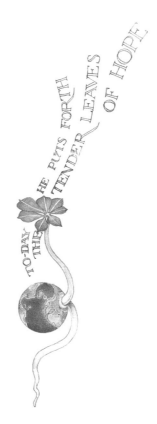

TO-DAY THE HE PUTS FORTH TENDER LEAVES OF HOPE

WILLIAM SHAKESPEARE
KING HENRY VIII

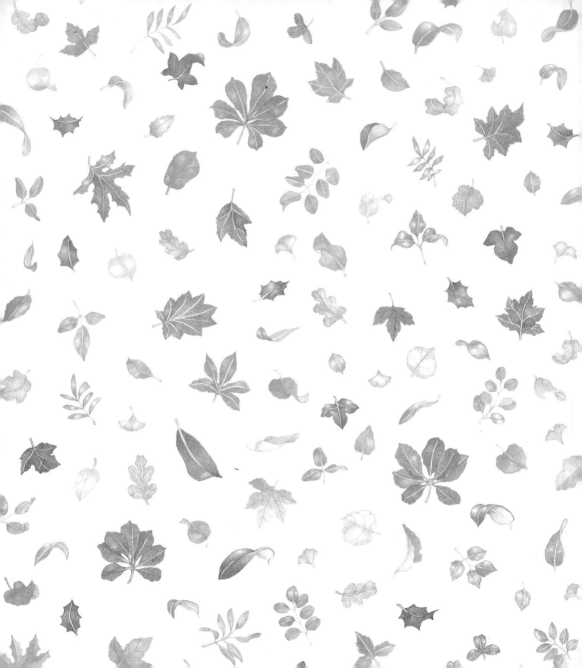